Salamander: *A Bestiary*

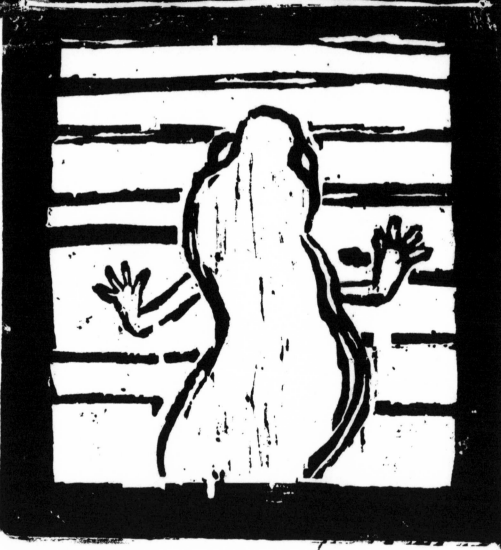

Salamander: *a Bestiary*

Leonard Schwartz

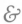

Simon Carr

chax
2017

ISBN 978-1-946104-07-6

Chax Press first edition 2017.

Chax Press / PO Box 162 / Victoria, TX 77902-0162

Chax Press is supported in part by the School of Arts & Sciences at the University of Houston-Victoria. We are located in the UHV Center for the Arts in downtown Victoria, Texas. We acknowledge the support of graduate and undergraduate student interns and assistants who contribute to the books we publish. In Spring 2017 our interns and assistants are Julieta Woleslagle, Ben Leitner, and Gabrielle Delao. Chax books are also supported by private donors. We are thankful to all of our contributors and members.

Please see http://chax.org/support/ for more information.

Thanks to the PSC/CUNY Awards Program for providing funding to make parts of this project possible.

Contents

Introduction

Ten frogs, trapped in a transparent glass coffee pot.

My daughter Cleo caught nine of them. I caught the other.

There is a ravine up in Washington State's Capital Forest that is teeming with frogs. Now nine frogs sat in the pot, apparently dour of expression, as I anthropomorphized their countenances and circumstance.

Sometimes they would all try to jump out at once, bumping their heads against the soft plastic top of the coffee pot.

Immediately after we got home from the forest with the frogs I returned an email message from the painter Simon Carr, and mentioned to him in passing *ten frogs in a coffee pot*. Later Cleo and I released the frogs by the bank of the stream that runs through a ravine nearer our house. Later that night Simon wrote back to say that because of the frogs in the coffee pot we had to do a bestiary together. Or did Simon write to say we had to do a bestiary together, after which Cleo and I went out and set the frogs free?

I don't remember. I do know that because of the frogs in the coffee pot Simon suggested the idea of a bestiary, and that I jumped at it. Because our relationship to the animal is often characterized by entrapment and confinement, by detachment and blindness, I wanted to imagine another way. Of course we were planning to release the frogs even without the proposal of making a book,

but what followed for me and Simon was a back and forth about capture and release, such that I wondered about the order of events.

I do know I would send Simon a poem and he would send me back a drawing; once or twice it happened the other way around.

As animals ourselves we try very hard to contain the animal, to seal the animal off: in zoos, in works of art, in disguises, in slaughterhouses, in coffee pots, in definitions of ourselves that leave out the animal. But in containing the animal we also risk killing it, immediately or in the long term. So the animals always seem to elude us, no matter how much we hold or touch or meddle in their affairs, no matter how much we either highlight or deny the presence of the animal in our own affairs. If we release it, it loses resemblance, and if we contain it, we force an identification.

To Simon the poems I sent suggested woodcuts. His drawings became studies for those woodcuts.

The contrast in a wood cut between light and dark allows for ambiguities of representation between animal and void, contained and container, capture and release, opened and closed, conscious and unconscious.

It is true that we think about magic gaps.

Are there in fact such gaps on the basis of which an animal can be contained and uncontained, perceivable and mysterious, body and abstraction, identity and energy?

Later on we decided frog was best represented by salamander, equally amphibious, latent with suggestion in the history of the form of the bestiary, yet ready at hand.

We had arrived at *Salamander: A Bestiary*.

Leonard Schwartz

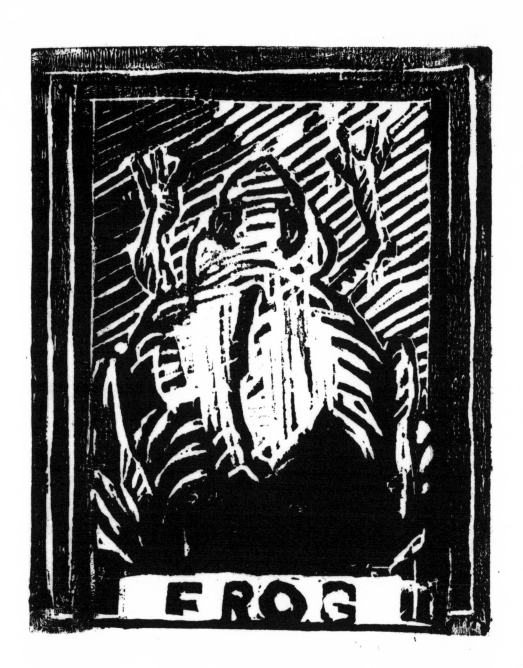

Frog

If we are like the frog

We may be in big trouble

For one we spent

The whole summer

Catching frogs

And for another

Well,

You know the rest.

(A guy I know got on his knees

And prayed to Jesus in his tub

And I don't think his skin is nearly

As sensitive as theirs is.)

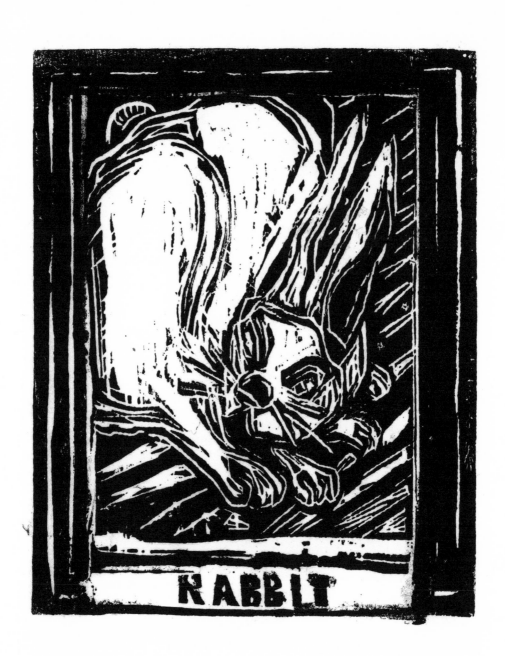

Rabbit

What is the rabbit's

Achilles heel, Cleo asks.

In fable it is overconfidence,

In morality plays being oversexed.

If the everyday is the ground of the unique

And ability leaps from habit like a sudden rabbit

Or possible hare...

Raven

Amazingly

A raven is seen

In the

Turbulent border

Between

Telos and boredom.

Rain pounds

That unmoving raven.

Only when crows come

Does the raven flinch.

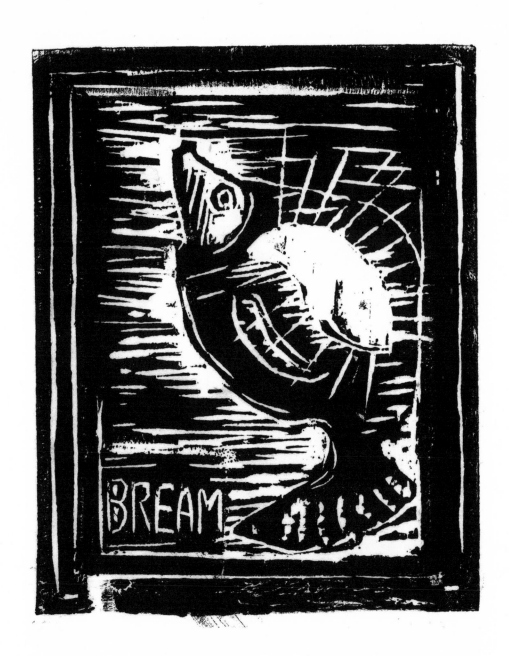

Bream

I once saw a *bream* get a heart transplant;

The surgeons put inside him the heat of a star.

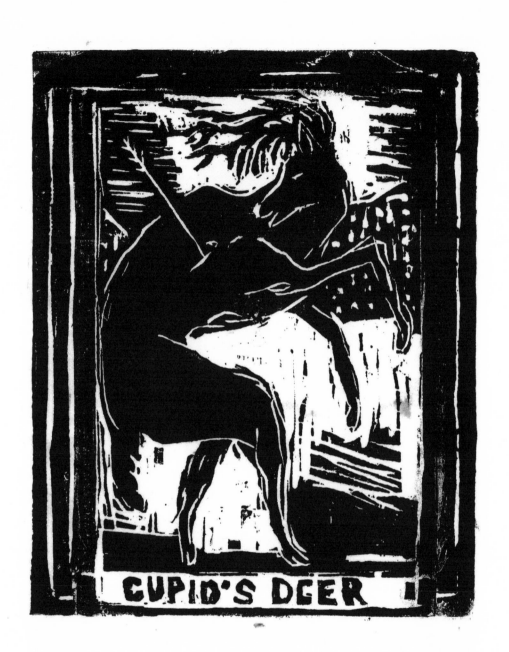

Cupid's Deer

Also I shot a deer the other day

With a cross-bow, for getting

Too close to my wife's garden.

I was almost as shocked as the deer

Who did a double take and bolted off

An arrow in his side: I was struck

By my own prowess, and my stupidity.

If afterwards the deer lay down to die

Curled around that shaft in some hidden thicket

That casual shaft and central pain are

My doing, as animals are mirrors reflecting back

Animals to themselves…

And other pieties

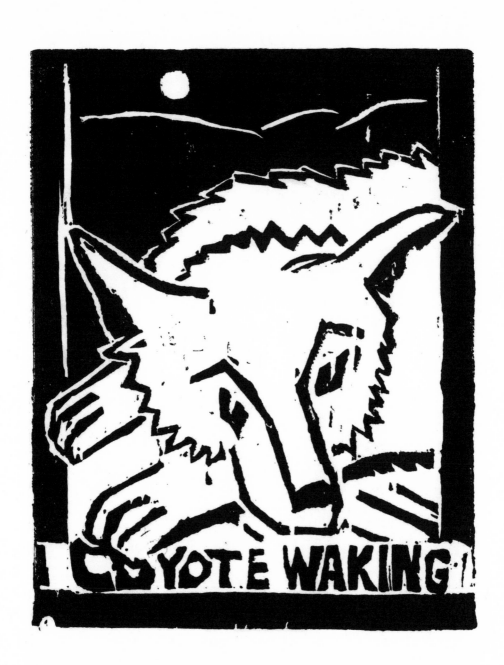

Coyote Waking

Once the coyote is awake you can see

the crazy intelligence in her eyes.

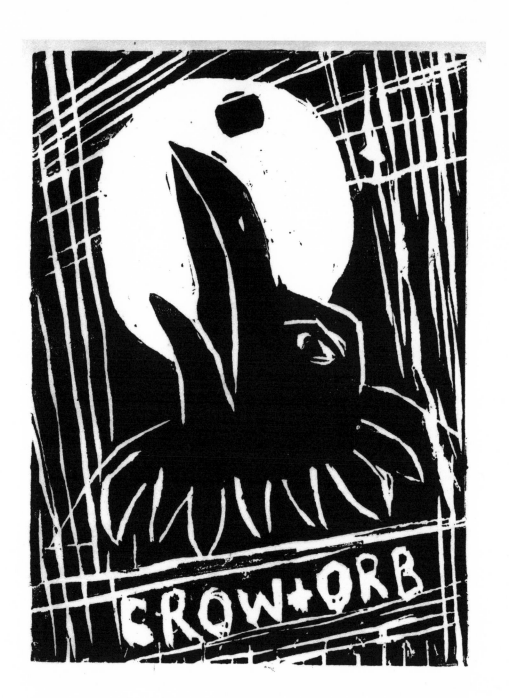

Crow and Orb

A crow looked through an orb

And saw doctors in scrubs

All working around a table.

Sensing the crow

One of the doctors turned his head.

This surprised the bird.

It had imagined it could not be seen.

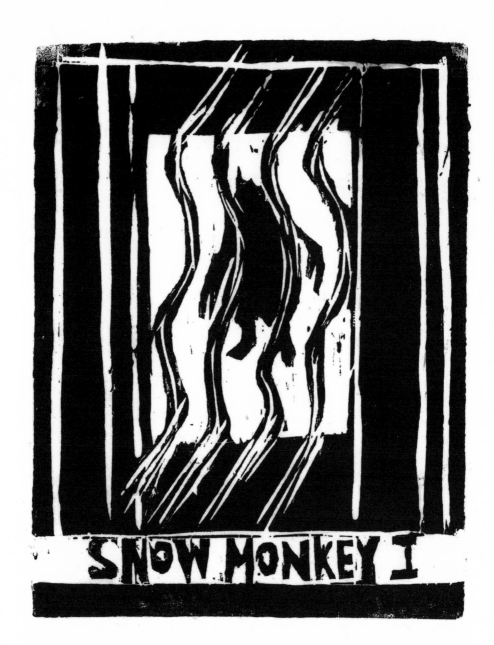

SNOW MONKEY I

Snow Monkey I

Continuous revelation of,

no subject but light.

Too, tied to the stake

 of foundational doubt.

Steam off rocks of this perception.

And snow monkeys. On their thrones.

Of stone. In the steam. Illuminated.

Action taken equals miracle.

Steaming stake.

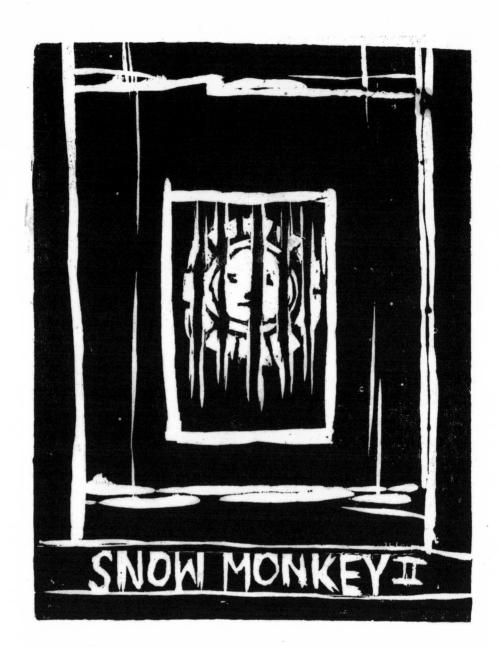

Snow Monkey II

Figures on a stage

that lead miniature lives, zoo creatures

in the action of language

Wildness withheld, hope to uncover

The being outside the bars

at labor in the steam off those waters.

So when the song is sealed,

let variously dispersed elves

Congregate

Let the ale in a glass, amber in color, be drunk

And be replaced with ale, equally amber

Equally amber

Until the snow monkey until the snow monkey

until the snow monkey.

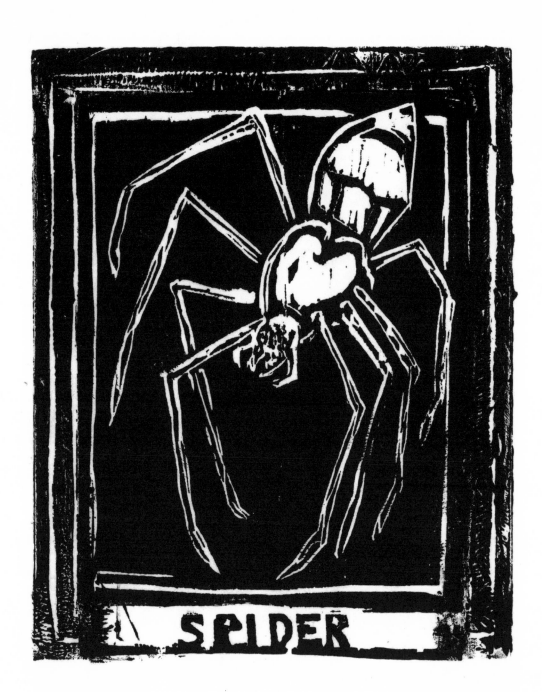

Spider

One hundred and eleven Confucian scholars

can't help me think

clearly

about what that spider

is working on just

Over there

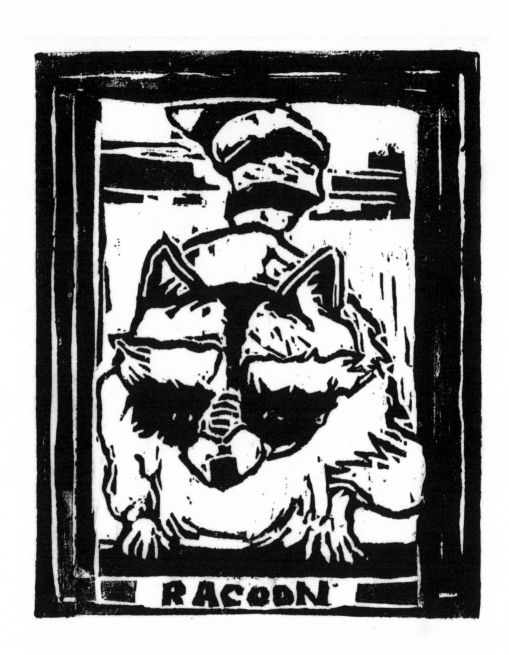

Racoon

Racoons have really, really hard heads.

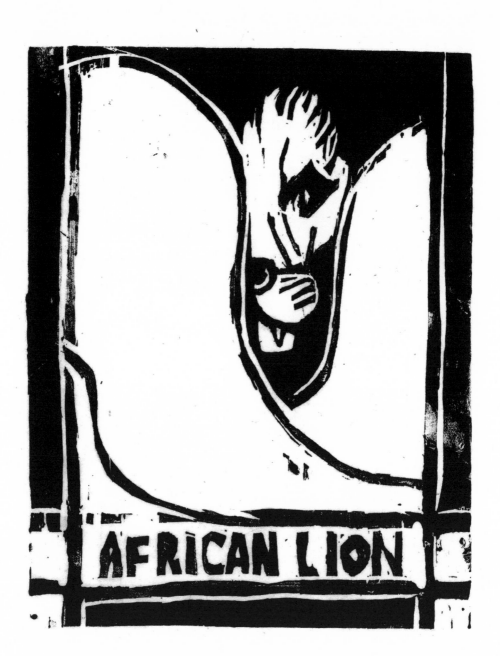

African Lion

A man left his pet lion on the top of a mountain in the Olympics. It had grown too large. This was no mountain lion, it was an African lion, the kind with the mane, the sort one expects to find out on the savannah. It was a very big mountain, and the man thought its heights well hidden. But he got caught, by a ranger. The lion growled from a snow drift. The ranger was ticketing the man, all the while eyeing the big cat, and calling for back up. It was a pretty bad scene.

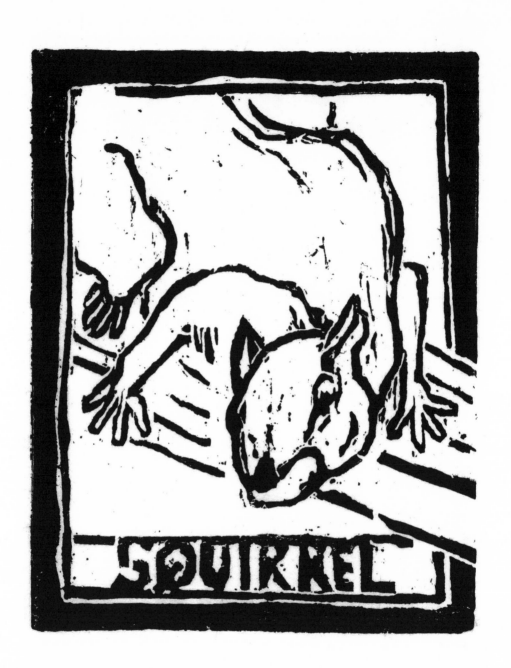

Squirrel

The squirrels around here love to tease and tease,

 to chatter

And taunt from the tops of the trees.

Though we try to catch them

They are never caught...

(Later one was transpierced.)

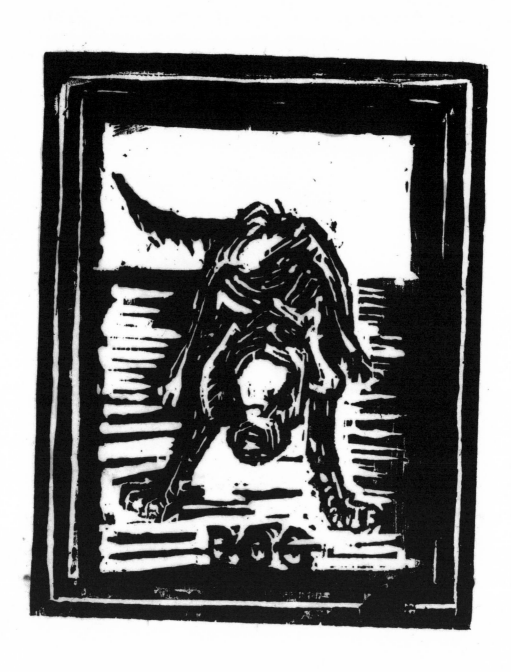

Dog

People always want to make dogs self-identical. To dogs. To themselves. But it isn't true. Dogs are not dogs. Dogs are not persons.

Dogs are not dogs.

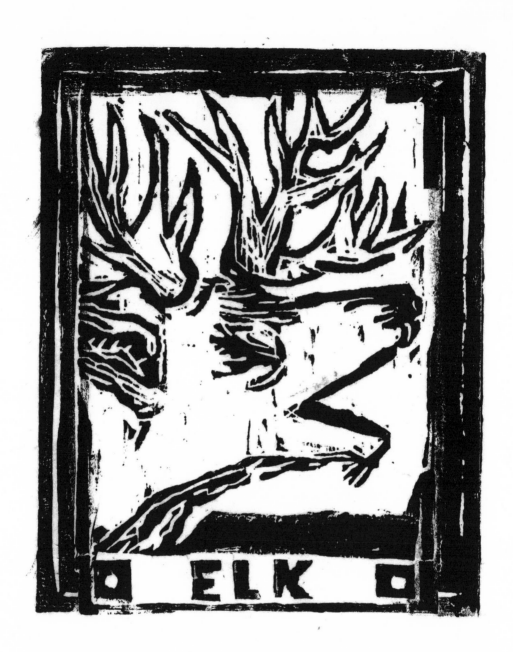

Elk

Sadly, the ocean has faded from our view

Of late.

Right up to the horizon all we see

Has the solidity

Of elk.

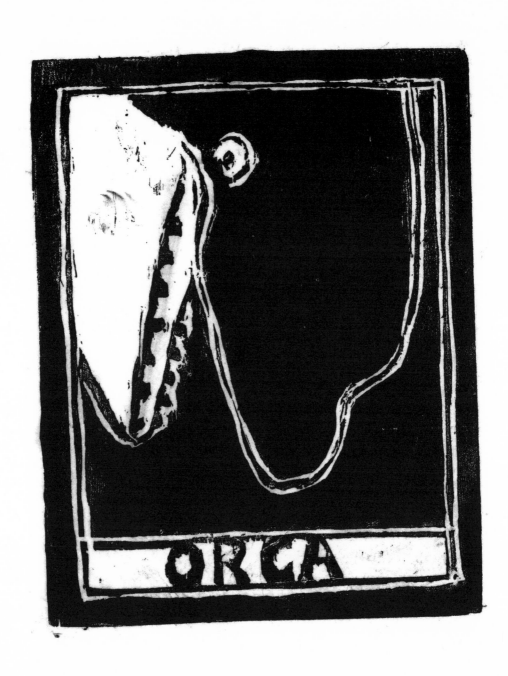

Orca Calf

To have bones spongy and light

With space for air, and with double flukes

Lifted high, tucking her head one dives

Into the depths in search of food and death!

Who releases into boundless space

Where the drink around her is immortal

And collects a lost landscape to which

She has actually returned, oceanic feeling

Her actual circumstance, within the mother

Of us all, direct communication likely.

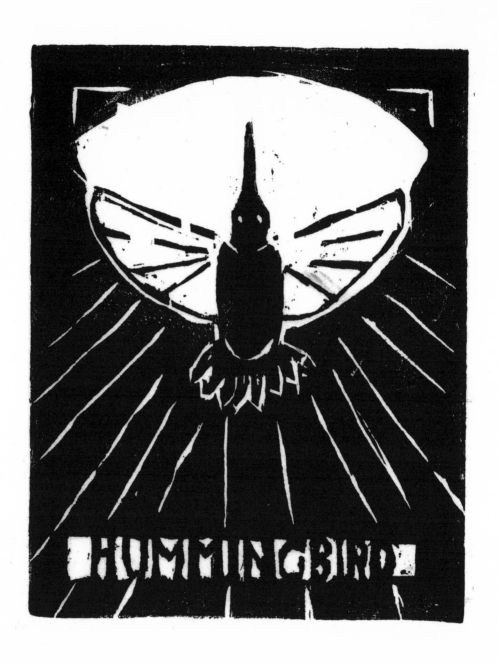

Hummingbird

A boat the size of a hummingbird

Pushes off into the Pacific.

Black, like ink from a bleeding pen.

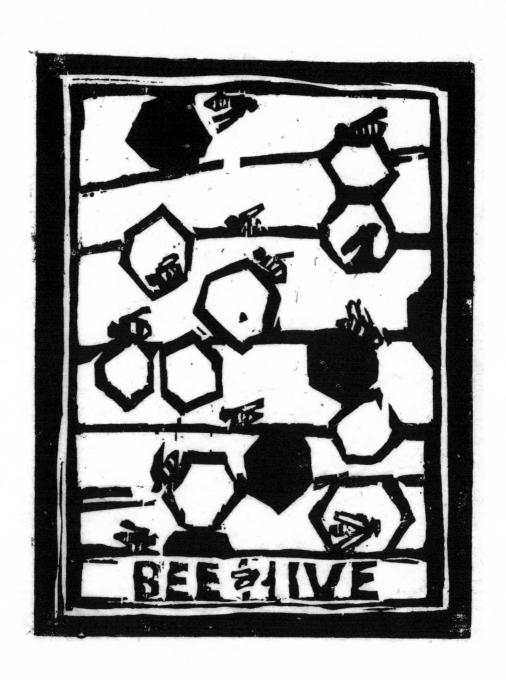

Bee Hive

Leaving out of Laguardia? Nah, Newark.

In the city each window houses an

Active bee hive.

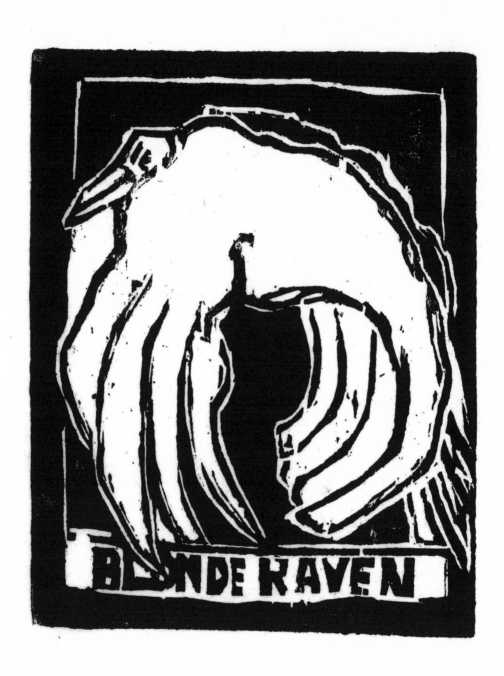

Blonde Raven

A blonde raven, not driven by rules

Anyone of us can obey or even recognize,

Disrupts the color in everything else.

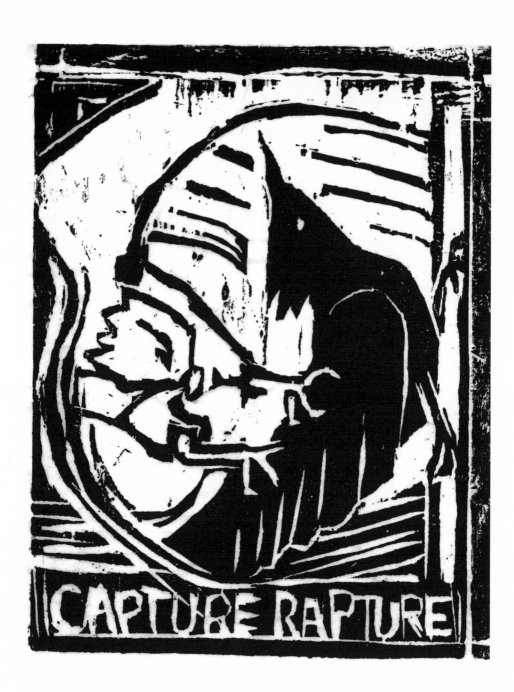

Capture Rapture

Because in mid-flight

Falcon seized jay and

I'm the jay and the gyre.

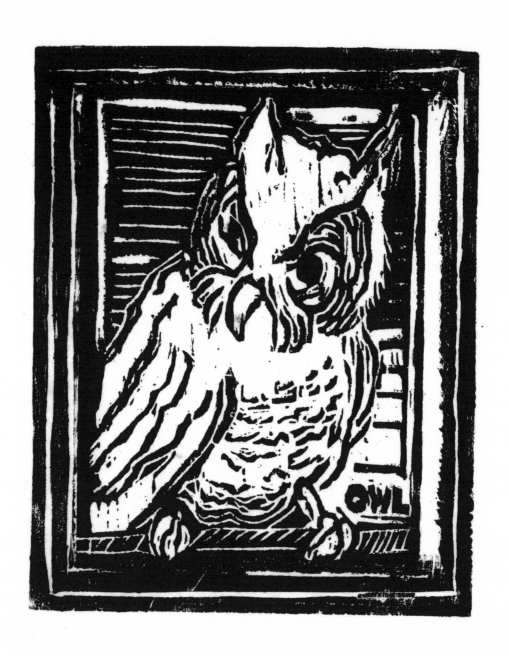

Owls

occupy certain dark niches of our common space, from which they
regard each movement of the human body with a certain interest
one can't quite call dispassionate.

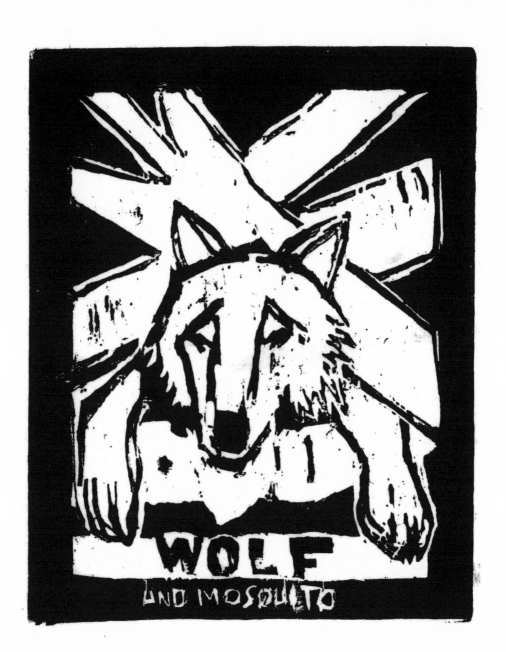

Wolf and Mosquito

Separated from her pups in the den

A red wolf pants

At the threshold of the thicket.

Closing a book

With purposeful speed

I crush a mosquito.

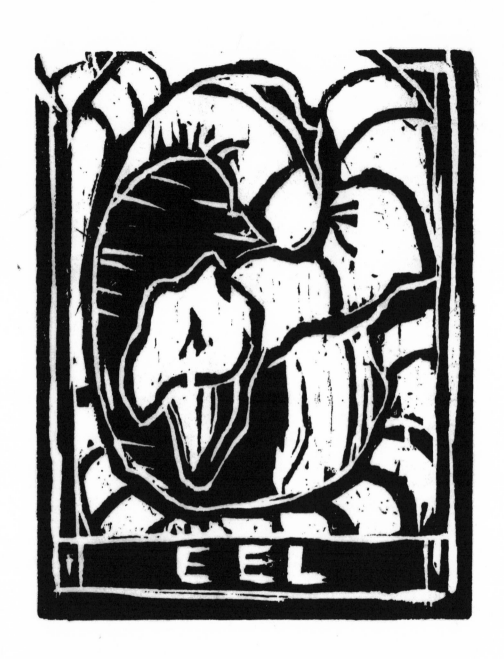

Eel

Because Nature is a frame

One could also call

An eel.

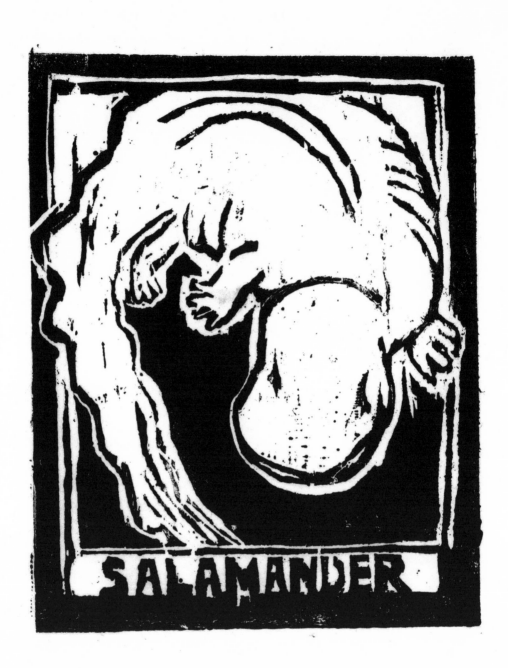

Every Salamander

We encounter

Suggests the possibility

Not only alchemy

Survives

But we will too,

If only we learn to make our skin

As poisonous as theirs

At all the right moments,

Not internalizing one little bit

Of the necessary defense.

(It isn't easy,

Not internalizing

Necessary poisons

For one's own defense.)

About the Author & Artist

Leonard Schwartz's most recent book is *The New Babel: Towards a Poetics of the Mid-East Crises* (University of Arkansas Press).

Other titles include *At Element* (Talisman House) and *A Message Back and other Furors,* also from Chax.

Simon Carr is a painter living and working in New York City.

Other recent illustration projects include: *Nostromo,* a novel for children and adults, by Sam Carr, illustrated by Simon Carr (Orbis Books, New York City, 2015).

Since 2015 he has been represented by the Bowery Gallery, 530 W. 25th St, New York, New York 10001, www.bowery.org.

More information can be found at the web site simoncarrstudio.com.

About CHAX

Founded in 1984 in Tucson, Arizona, Chax has published 200 books in a variety of formats, including hand printed letterpress books and chapbooks, hybrid chapbooks, book arts editions, and trade paperback editions such as the book you are holding. In August 2014 Chax moved to Victoria, Texas, and is presently located in the University of Houston-Victoria Center for the Arts, which has generously supported the publication of *An Intermittent Music*, which has also received support from many friends of the press. Chax is an independent 501(c)(3) organization which depends on support from various government and private funders, and, primarily, from individual donors and readers.

Recent and current books-in-progress include T*he Complete Light Poems*, by Jackson Mac Low, *Life–list*, by Jessica Smith, *Andalusia*, by Susan Thackrey, *Diesel Hand*, by Nico Vassilakis, *Dark Ladies*, by Steve McCaffery, *What We Do*, by Michael Gottlieb, *Limerence*, by Saba Razvi, *Short Course*, by Ted Greenwald and Charles Bernstein, *An Intermittent Music*, by Ted Greenwald, *Arrive on Wave*, by Gil Ott, *Entangled Bank*, by James Sherry, *Autocinema*, by Gaspar Orozco, *The Letters of Carla, the letter b.*, by Benjamin Hollander, *A Mere Ica*, by Linh Dinh, *A Night in the Sun*, by Will Alexander, and *Visible Instruments*, by Michael Kelleher.

You may find CHAX online at http://chax.org